# In the time of Warhol

## THE DEVELOPMENT OF CONTEMPORARY ART

© Aladdin Books Ltd 2002

*Designed and produced by*
Aladdin Books Ltd
28 Percy Street
London W1T 2BZ

*First published in the United States in 2002 by*
Copper Beech Books,
an imprint of
The Millbrook Press
2 Old New Milford Road
Brookfield, Connecticut 06804

ISBN 0-7613-2714-2 (lib. bdg.)
ISBN 0-7613-1629-9 (trd. pbk.)

*Cataloging-in-Publication data is on file
at the Library of Congress.*

*Printed in Belgium*

*Editors*
Leen De Ridder, Kathy Gemmell, Liz White

*Design*
Flick, Book Design and Graphics

*Picture Research*
Brian Hunter Smart

*Picture Credits*
Abbreviations: l-left, r-right, b-bottom, t-top, c-center, m-middle
*Courtesy of AKG London*
Front cover, 3, 24br, 26—© The Andy Warhol Foundation for the Visual Arts, Inc./ARS, NY and DACS, London 2002. 5tl, 8tl, 8br—Kate Rothko Prizel and Christopher Rothko/DACS 1998. 6tl, 7b, 9b, 10tl, 16tl, 18 both, 46tr, 48b—© ARS, NY and DACS, London 2002. 6br, 14b, 17bl, 28 both, 33—© ADAGP, Paris and DACS, London 2002. 20 both—© Jasper Johns/VAGA, New York/DACS, London 2002. 22br—© Richard Hamilton 2002, All rights reserved, DACS. 23t—© The Estate of Roy Lichtenstein/DACS 2002. 24tl—© Licensed by The Andy Warhol Foundation for the Visual Arts, Inc./DACS, London 2002. Trademarks Licensed by Campbell Soup Company, All Rights Reserved. 27tl—© The George and Helen Segal Foundation/DACS, London/VAGA, New York 2002. 34mr—© DACS 2002. 36tl—© 2002, All rights reserved, DACS. 42 both—Schütze/Rodemann. 43— Dieter E. Hoppe. 45—© Louise Bourgeois/VAGA, New York/DACS, London 2002. 10mr, 12tl, 12br, 13b, 19bl, 22tl, 27bl, 30tl, 32tl, 34tl, 35, 36br, 37, 38mr, 40 both, 47b.
*Courtesy of the Tate Picture Library*
41, 44br.
*Courtesy of Corbis*
4c, 25b—Douglas Kirkland/CORBIS. 11mr, 15bl—Wolfgang Kaehler/CORBIS. 21bl—Michael Freeman/CORBIS. 29bl, 47tr—Christine Osborne/CORBIS. 30br—Burstein Collection/CORBIS. 31—Catherine Karnow/CORBIS.
*Others*
5b, 44tl—Gateshead Council. 14tl, 15tl, 46c—Reproduced by permission of the Henry Moore Foundation. 32bl—Select Pictures. 38tl—Richard Long. 39—Peruvian Embassy.

# ART AROUND THE WORLD

# In the time of Warhol

WITHDRAWN

## Antony Mason

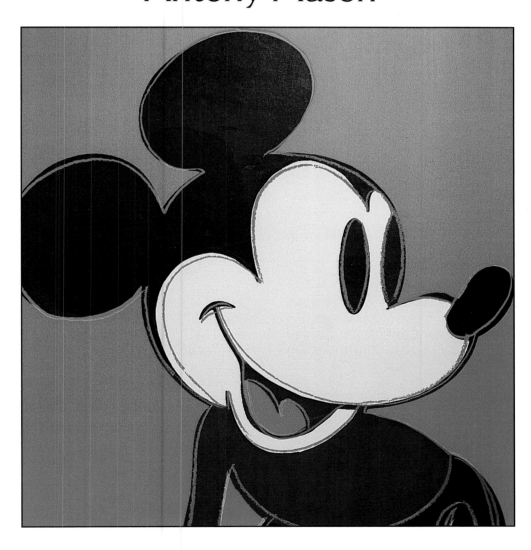

Copper Beech Books • Brookfield, Connecticut

# Contents

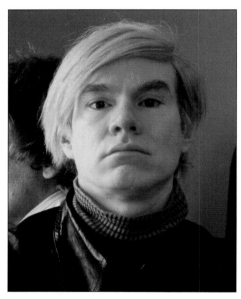

# Introduction

After the end of World War II (1939-45), the focus of Western art shifted from Europe for the first time. Now the leading superpower, the United States was also attracting the attention of avant-garde European artists, who began tracking what American artists were doing. Many of the art trends of the late 20th century, from Abstract Expressionism to Minimalism, Pop Art, Superrealism, and Land Art, developed and flowered in the United States. Inspired by the work of a number of pioneers and art movements of the early 20th century, such as Marcel Duchamp, Constantin Brancusi, and the Dadaists, a new generation of artists set out to challenge traditional concepts about art. By the end of the century, the art world was wide open to all kinds of new ideas and materials, and was truly international.

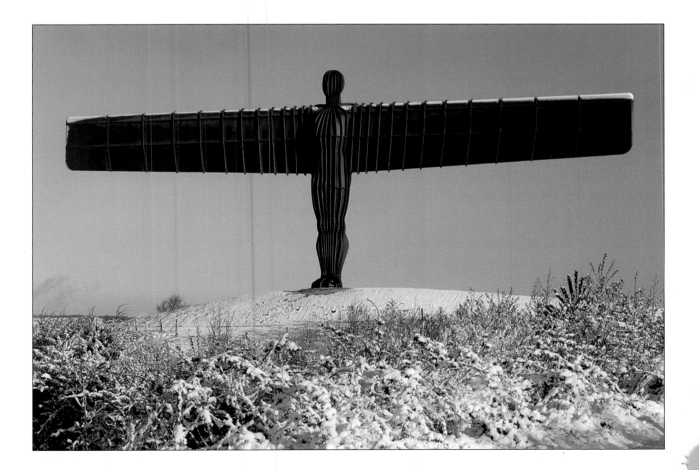

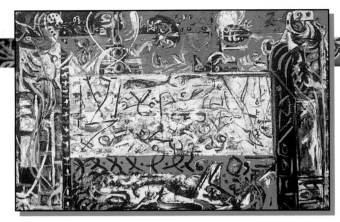
Guardians of the Secret (1943), by Pollock.

# Abstract Expressionism

During the 1930s, the world suffered a deep financial crisis known as the Great Depression. In the U.S., the government supported struggling artists by funding the Federal Art Project. At the same time, many leading European artists arrived in America, fleeing the Nazis and war. These events created fertile ground for the development of modern art in the U.S., especially in New York City. One artist heavily involved in the New York art scene was Jackson Pollock (1912-56). He combined abstract art with German Expressionism and with a Surrealist exploration of the subconscious mind. The result was Abstract Expressionism, which remained popular well into the 1960s.

## Drip and splash

During the 1930s, Pollock had been interested in Surrealism. One aspect of Surrealism was "automatic" painting and writing—simply taking a brush or pen, letting the mind run free, and creating, with no planning and without trying to control the result. This was said to tap directly into the subconscious mind.

Pollock followed this procedure and gradually came to the conclusion that the most direct expression of the subconscious mind was not the finished work, but the act of painting itself. His work became looser and more abstract. In 1947, he abandoned any kind of controlled form or reference to the real world. Instead he just dripped, dribbled, and splashed paint over the canvas—his "drip and splash" technique. No one had yet approached painting with this level of abandon.

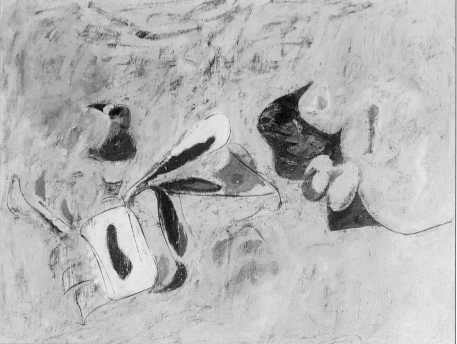

Above: Apple Orchard (1943-46), by Gorky. This painting shows how Gorky provided a link between the Surrealism of artists like Joan Miró and Abstract Expressionism.

Right: The Wooden Horse (1948), by Pollock. This work uses just five colors on gray.

Previous abstract artists, such as Mondrian and Malevich, had controlled shape and color to convey the desired effect. Pollock let chance play a large part in his work, and much of it exists as a record of the process, rather than an object of beauty in itself. The raw energy, great color sense, and often delicate beauty in his work reflect perhaps the spirituality that he wanted to convey in the act of painting. Many art critics were outraged by Pollock's work. It seemed to be the opposite of all that was cherished in Western art—notably technical skill. He stopped drip-painting in 1951 and returned to more figurative work, but was killed in a car accident in 1956, at age 44.

Among other artists that took up Abstract Expressionism was Arshile Gorky (1904-48), an American of Turkish-Armenian origin. Like Pollock, he was initially attracted by the Surrealists. Gorky died in 1948, also at age 44.

# Action painting

In 1952, the term "action painting" was coined to describe the way that some Abstract Expressionists worked, in which the process of painting was as important as the final work. Jackson Pollock provides the most famous example of this method. Because the end result depended to a large degree on the haphazard position of wet paint, he used to lay his large canvases on the ground. "On the floor I am more at ease," he said. "I feel nearer, more part of the painting, since this way I can walk around it, work from the four sides, and literally be in the painting." With his mind in free-flowing, creative mode, he would take large cans of industrial paint and slop it on freely, performing a kind of dancing motion and allowing his subconscious to make decisions about where to place the paint, when to start, and when to stop. He also used knives and sticks to move the paint about, sometimes adding sand to alter the texture. As Pollock put it, "When I'm in the painting, I'm not aware of what I'm doing . . . the painting has a life of its own."

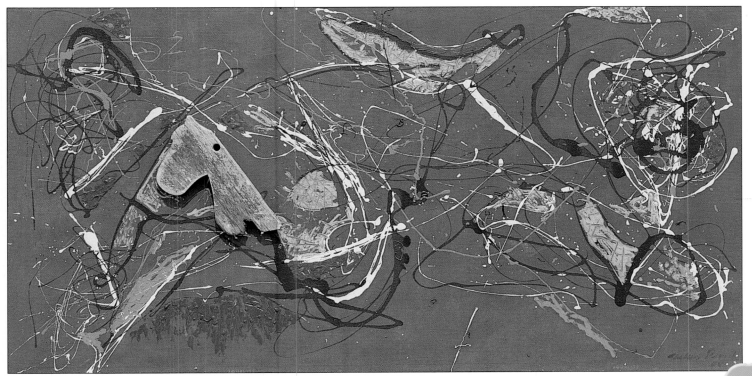

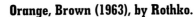

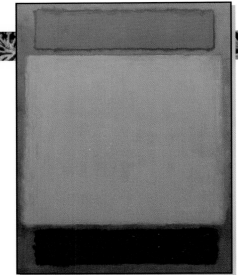

# Color Field

One form of Abstract Expressionism used blocks of pure color, often with fuzzy edges. The leading painter of this style, known as Color Field, was the Russian-born American artist Mark Rothko (1903-70). His large works look simple, but represent a series of careful judgments about shape and color, and the relationship between them. Unlike Pollock, Rothko painted with delicate brush strokes, building up colors in layers. At first glance, Rothko's work seems to show less turmoil than the "action painting" of Jackson Pollock, but it expresses much pent-up tension and emotion.

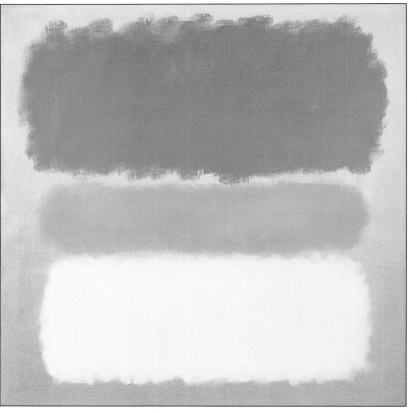

## Glowing color

Rothko arrived in the U.S. as a child, in 1913. Although he studied art in the 1920s and was influenced by Expressionism and Surrealism, he considered himself virtually self-taught. He developed his distinctive style in the early 1950s, using rectangles of pure color applied with painterly expressiveness. His works are usually large—Orange, Brown (above) is 7.5 ft (2.26 m) tall. The size and boldness of design give the paintings a monumental, haunting quality, with the colors seeming to glow and float on the background.

Untitled (1957), by Rothko. Although Rothko tended to limit his paintings to a few colors, a distinctive feature of his work is the way in which it appears to glow and pulsate.

Like Pollock, Rothko believed that painting was a semireligious event, and that the emotional act of painting transferred to his work. "I am only interested in expressing basic human emotions," he claimed. "Tragedy, ecstasy, doom and so on." His work also produced emotional responses, even tears, from viewers.

It took a while for the public to appreciate Rothko's work, but his career took off in the 1960s. However, he suffered increasingly from depression, made worse by alcohol and drug abuse and two failed marriages. The somber tones of his later works reflect a growing despair, which led to his suicide in 1970.

During the 1940s, the American artist Barnett Newman (1905-70) was also in search of a kind of religious ecstasy. He painted brushed color fields similar to Rothko's, although his work generally provokes a cooler emotional response. A distinctive feature was his thin vertical lines, which he called "zips." In his later work, the field of color became smoother and the lines crisper. During the 1960s, he began making abstract steel sculptures, with emphasis on neat, vertical precision.

Newman felt that abstract art could express any subject that representational art had depicted in the past. In 1965-66, for instance, he painted *The Stations of the Cross* (the story of Christ's crucifixion) as abstract paintings.

Newman summed up the liberation abstract painting offered, "We are freeing ourselves of the impediments of memory, association, nostalgia, legend—of Western European painting."

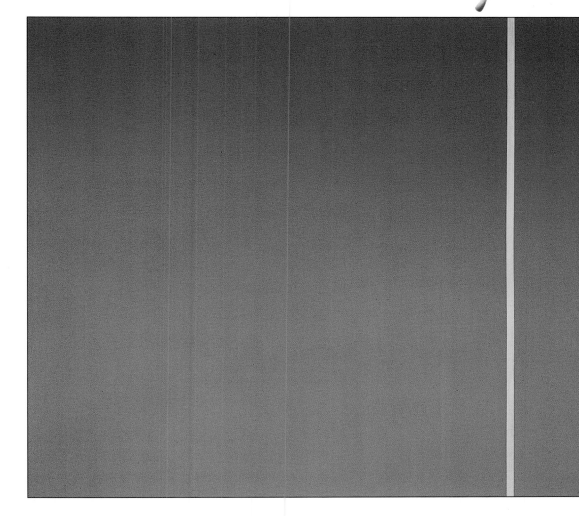

**Midnight Blue (1970), by Newman.** One of his last paintings, it still retains Newman's hallmark—the vertical "zip." In his later years, he reduced the evidence of his brush strokes to create a much smoother finish. This kind of precise abstraction refined the artist's creative input to two main factors—the selection of color and the positioning of the elements. The success of this piece is in its great sense of calm and the feeling of satisfaction that it evokes. The two factors, color and positioning, seem just right.

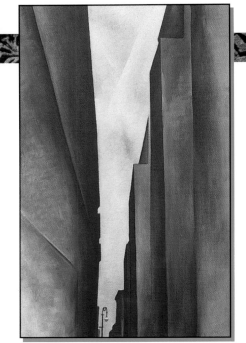

# American Realism

During the 19th century, a number of gifted painters in the U.S. had established a style of painting said to be essentially American. In the 1920s, several artists preserved this tradition yet found their own voice. The city became a central theme. Charles Sheeler (1883-1965) painted people-less cityscapes of New York in a semi-abstract style influenced by Cubism, yet with such hard-edged precision that it was later labeled Precisionism. Another leading figure in this movement was Georgia O'Keeffe (1887-1986), who became America's best-known woman painter.

## Life in America

Georgia O'Keeffe was at the forefront of contemporary art in New York in the 1920s, absorbing into her painting influences from European trends. She pioneered abstract art as early as 1915, but later moved toward a more figurative style. From the 1930s, her paintings increasingly featured the desert landscape of New Mexico, where she moved in 1946. This work often focused on details, such as flowers, rocks, and bones, painted in a precise but semi-abstract way, often with a Surrealist edge.

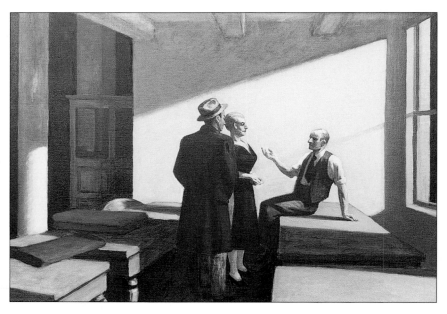

Conference at Night (1949), by Hopper. This painting is unusual for Hopper, in that it has three figures. Most of his paintings have just one. As in most of Hopper's work, the figures are seen as if through a window and appear remote from the viewer. It is as though we are eavesdropping on a mysterious late-night conference, lit from outside by streetlamps.

There were no abstract qualities in the paintings of Edward Hopper (1882-1967). Avant-garde trends in Europe had little effect on his work. In the 1920s, he developed a style of almost photographic exactness. His work quickly won public attention, and by the 1930s he was a well-known artist.

# Around the World
## Bali

The Hindu island of Bali, Indonesia, is famous for its strong artistic traditions, expressed in painting, stone- and wood-carving, as well as in dance and music. Originally, all artistic activity was an act of devotion to the gods. Bali's wealth of tradition and talent first became known to the wider world in the 1920s, and attracted many foreign artists and writers, thrilled by what they found.

### Give and take

Balinese artists have always been quick to absorb traditions from elsewhere in the world. In the 1920s and 1930s, they learned oil painting and watercolor techniques from visiting artists, as well as the concept of creating signed paintings for sale. They adapted Western styles of art to their own, highly individual artistic vision. In painting, this resulted in very intricate compositions, crammed with details of daily life, often humorous. This tradition continues today.

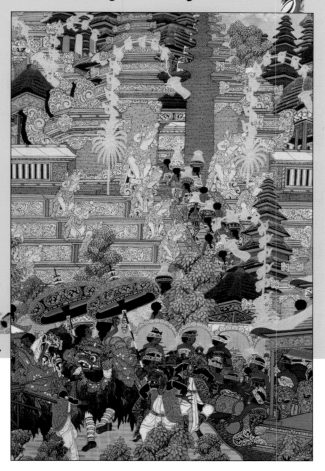

A modern painting featuring a Hindu goddess dressed in Balinese style.

Hopper's settings—apartment houses, gas stations, and cafeterias—come straight from contemporary America. But his work has a distinctive bleakness to it. The colors are limited and subdued, shadows are long, and the scenes often take place at night. One of Hopper's central themes was the loneliness of city life. The figures are small in comparison to their surroundings. They often express a certain emotional tension, which evokes a sense of mystery, or menace.

A loosely defined group, the American Scene Painters, emerged in the 1920s and 1930s, comprising painters who were not part of the avant-garde trends of the time, notably abstract art. Hopper is sometimes said to be an American Scene Painter, but he resented this label. The Regionalists appeared at the same time, a group that painted nostalgic images of rural life in the Midwest during the Depression of the 1930s.

Edward Hopper was fascinated by the new popular medium of the era—the movies—and many of his paintings look like "stills" taken from films.

# Photography

Even in its early days, back in the 1850s and 1860s, the pioneer practitioners of photography felt that it had the potential to become an art form. The Dadaists and Surrealists, notably the American Man Ray (1890-1976), used photography to create strange and artistic images. But in the 1920s, a more naturalistic use of photography demonstrated that art photography could also be created by taking pictures of the real world. Previously, photographs of landscapes, people, or objects had been compared to paintings. Now, it was acknowledged that photographs (still mainly black-and-white) had their own quality, independent of painting.

## The photographer's eye

Many of the pioneers of this new photography were American. They included Paul Strand (1890-1976), Edward Weston (1886-1958), Edward Steichen (1879-1973), and Ansel Adams (1902-84). Alfred Stieglitz (1864-1946), a gifted photographer, was the owner of the 291 Gallery in New York, where photographs were exhibited alongside works by leading artists, such as Picasso and Matisse. In 1924, Stieglitz married the painter Georgia O'Keeffe.

Much of the work of these photographers concerned landscape and portraits presented in beautifully crafted images.

Tina Modotti was a member of the Mexican Communist Party. She was accused of being involved in an assassination attempt on the president in 1930, and forced to leave Mexico.

Above: Girl Fetching Water, Mexico (1926), by Tina Modotti. Her work was noted for its powerful sense of composition and often carried a strong social message.

Several of the photographers became known for the social comment in their work. During the 1930s, Dorothea Lange (1895-1965) recorded the hardships of the unemployed and migrant workers. Italian photographer Tina Modotti (1896-1942) traveled to Mexico with Edward Weston and made moving studies of the struggles and dignity of Indian women.

Other leading European photographers included the Frenchmen Henri Cartier-Bresson (b.1908) and Robert Doisneau (1912-94) and the Briton Bill Brandt (1904-83).

# Seize the moment

Improvements in camera technology made photographers increasingly mobile. In the 1870s, they had to use huge cameras that captured the images on large glass plates, but the invention of rolls of celluloid film in 1889 permitted the invention of light, portable cameras. Henri Cartier-Bresson used a small Leica camera for most of his work. He explained his approach to photography in the 1930s, "I prowled the streets all day, feeling very strung-up and ready to pounce, determined to 'trap' life—to preserve life in the act of living."

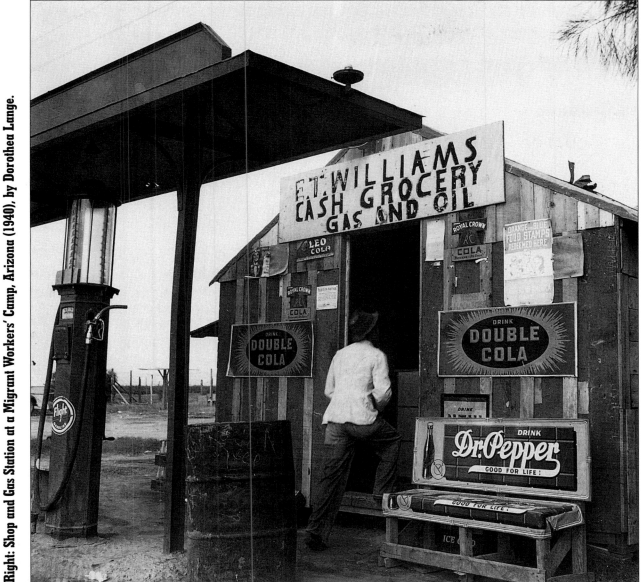

Right: Shop and Gas Station at a Migrant Workers' Camp, Arizona (1940), by Dorothea Lange.

# New Directions in Sculpture

Two highly influential artists had a major impact on sculpture in the early part of the 20th century. One was Constantin Brancusi (1876-1957) for his determination to reduce shapes down to essential forms. The other was Pablo Picasso (1881-1973), for his sheer inventiveness. They injected a new vigor into sculpture, which was greeted enthusiastically by a generation of younger sculptors. These included Britain's Henry Moore (1898-1986), Switzerland's Alberto Giacometti (1901-66), and the American Alexander Calder (1898-1976), each of whom responded in very different ways.

## Figures in space

In the 1930s, Giacometti produced wiry sculptures that recall Picasso's openwork constructions of welded metal rods. But during World War II, he took a new look at the human body. In 1947, he came up with the image for which he is now so well known—spindly, sticklike figures, cast in bronze. He modeled them in plaster of Paris on a wire base, and left the modeling rough before casting. The resulting figures seem to express fragility, nervousness, and suffering, as well as dignity.

**Place (Nine Figures): The Clearing (1950), by Giacometti. He called such groups "transparent constructions."**

When the figures are placed in multiple groups, the space between them underlines their emaciated shapes. They are reminiscent of the struggling survivors of Nazi death camps in World War II. Photographs of the liberation of the camps in 1945 haunted the world for many years after the end of the war.

**Rocking Chair No 1 (1950), by Moore. Even in this comparatively realistic piece, his interest in the spaces created by the shapes is clear.**

Henry Moore took a different approach to his sculpture. Although his starting point was almost always a real-life subject, he developed the shapes almost to complete abstraction. He was interested in the shapes that sculpture made in space—the "voids" pierced through the solid parts of the piece. His work has a sense of weight and monumentality, but is also full of life and human tenderness. A leading American sculptor of this era was David Smith (1906-65). Made of metal and bits of scrap, his large pieces show the influence of Picasso, but combine a delicacy and strength entirely his own.

# Around the World
# Arctic Canada

The Inuit, or Eskimo, culture is one of the oldest in the world. People have been living in the frozen far north of Canada for more than 12,000 years. The Inuit people used carving to make tools out of animal bones, walrus ivory, and driftwood. They sometimes decorated these with images of people or animals, and occasionally made carved figurines as children's toys.

**Rock-carving sculpture of an Inuit woman, from Cape Dorset on Baffin Island, Nunavut, Canada.**

## Art for sale

Since the 1950s, Inuit sculptors in Canada have been encouraged by the government to develop their skills as a means of earning extra income in a land where jobs are few and winters are long. Carving also helps to reinforce old Inuit traditions. Most modern Inuit sculptures are made from gray, blue, or green stone, or from whalebone. They usually feature people and animals carved in a rounded style, then polished smooth.

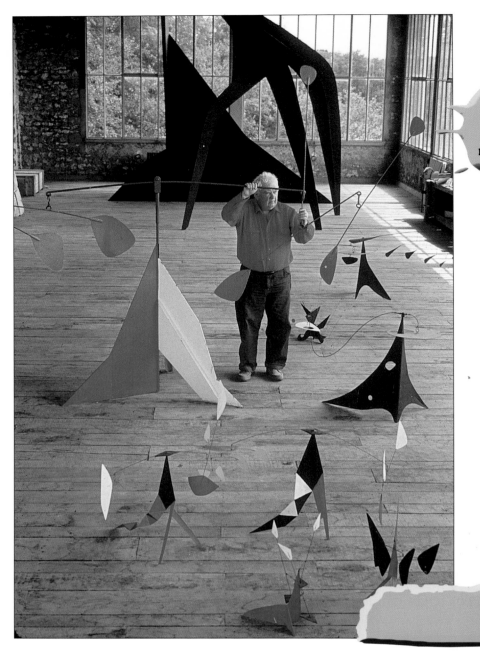

Alexander Calder, photographed in 1967 in his studio at Saché, near Tours, France. He is most famous for his mobiles, but he also made nonmoving "stabiles," which stood on the ground. Most of Calder's work was made with flat sheet-metal, and constructed at a foundry in Tours. He then painted the pieces in primary colors, and black and white. Calder divided his time between France and his studio at an old farm in Roxbury, Connecticut.

## Mobiles

### Sculpture that moves

Another artist inspired by Picasso's structures was the American Alexander Calder, who was living in Paris during the 1930s. He was also influenced by Russian Constructivist sculpture, and by the semi-abstract paintings of the Surrealists, notably the Spaniard Joan Miró (1893-1983), who became a close friend. He joined all these together and added another element: movement. Marcel Duchamp (1887-1968) and the Russian Constructivists had been experimenting with moving sculpture in the 1920s, but they had always thought of movement as driven by motors or clockwork.

Children often have mobiles hanging in their rooms. The word for these decorations was invented by Marcel Duchamp in 1932 to describe Calder's kinetic sculpture. That same year, the French sculptor and painter Jean Arp (1886-1966) also coined the term "stabiles." Calder's mobiles were made of sheets of metal, suspended on metal wires and rods. This means that they move easily, but they are also fairly strong. The simplicity of their construction conceals the considerable planning and experimentation that went into them, to achieve the right balance between the elements, and the desired spacing between them in all their possible positions. Calder's training as a mechanical engineer helped him to achieve the delicate effect of both balance and movement.

But Calder was the first to concentrate on movement, and he did so in an entirely new way. Delicately mounted and balanced on metal rods, his sculptures swung around in the slightest breeze, creating new shapes and spaces as they moved. Calder described them as "four-dimensional drawings." This concept unnerved the art world. Sculpture was supposed to be solid, immobile, and built to last. Now it was flimsy and delicate and it moved. Calder also encouraged viewers to touch and move his mobiles, contradicting the old "look but don't touch" approach to sculpture.

Although the Constructivists used the term kinetic (from the Greek, *kinesis*, meaning movement) in 1920, moving sculpture was not generally known as kinetic art until the 1950s. By this time, sculptors were using a number of means to create motion, including motors, electromagnets, and water power.

The Swiss artist Jean Tinguely (1925-91) used motors to drive his fanciful, humorous, and surreal constructions, often made out of pieces of junk. His deliberately wonky engineering poked fun at the machine age. In some of his pieces, he invited viewers not only to touch the work but to operate it.

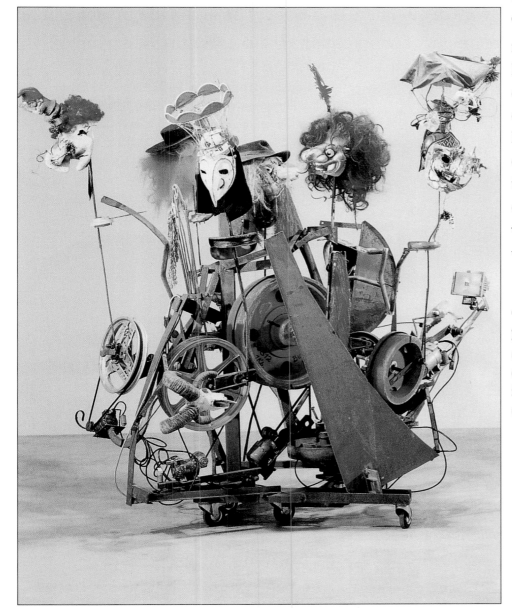

**The Avant-Garde (1988), by Tinguely. The world of avant-garde artists and critics comes in for some gentle mockery in this example of "junk sculpture" driven by a crude motor.**

# Minimalism

While the Abstract Expressionists like Jackson Pollock—heirs to the Fauvists, German Expressionists, and Surrealists—were dripping and splashing, another set of artists took a very different route into abstraction, inspired by the cool, geometrical work created in the 1920s by painters such as Piet Mondrian (1872-1944) and Kasimir Malevich (1878-1935). They seemed to suggest that "less is better." Could work of elegance and beauty be achieved by going farther down this path, using the minimum of intervention by the artist, the minimum of artistic expression, and the minimum of materials?

Ctesiphon III (1968), by Stella. He started using shaped canvases in the early 1960s to escape the constraints of the traditional rectangular canvas. This way, the patterns could be allowed to dictate their own form.

## Nothing more

In 1965, the term Minimalism was coined to describe this movement. The artists involved created sculptural works in neat, symmetrical shapes using industrial materials. One of the leading figures was the American Donald Judd (1928-94). In 1965, he made a large ramp out of perforated steel, called *Untitled*.

Perhaps the most notorious Minimalist work was a series of pieces called *Equivalents* (1966), by the American Carl Andre (1935-). The series consisted of sets of industrially produced firebricks laid on the floor in a long rectangle. In 1972, London's Tate Gallery purchased *Equivalents VIII* for a large sum of money, causing controversy, mockery, and public anger at the time. After all, it appeared that the gallery had bought little more than a set of bricks, which anyone could buy at a builders' supply yard for just a few dollars. But *Equivalents* posed serious and intriguing questions about the meaning of art, and the real value of works of art.

The American painter Frank Stella (b.1936) took Minimalism in a rather different direction. In 1959, he produced a series of "black pinstripe paintings"—thin black lines on a canvas. He soon began using shaped canvases, as in his *Claroquesi*. Later he introduced more color, sectioned off into neatly divided spaces. This approach gave his work a depersonalized look. A picture, he claimed, is just "a flat surface with paint on it." Since the 1970s, Stella's work has become more expressive, with more inventive cutout shapes bordering on sculpture, and graffiti-like paintwork.

American painter Ellsworth Kelly (b.1923) produced similarly neat abstract works in a style that was labeled "Hard Edge" painting. Essentially, he explored the relationships between color and form, in the most economic and pared-down way.

Meanwhile, the American Dan Flavin (b.1933-96) produced minimalist installations using colored fluorescent tube lights. True to Minimalism, his lights remain on and do not even flash.

## Working with lights

The concept of Minimalism can be traced back to Marcel Duchamp, and his use of ready-made industrial products (such as a bicycle wheel) in art. The use of lighting can be seen in similar terms—the fluorescent strip lights used by Dan Flavin are also ready-mades. The artist's input is simply to arrange them. Making art with light still has its appeal. It is used by British artist Martin Creed (b.1968). His work entitled *Work #227: The Lights Going On and Off* (2001) is simply that. In a bare, white-painted gallery, overhead lights go on and off. With this gesture, Creed shows how small the difference can be between a work of art and everyday experience of the world.

**Two Primary Series and One Secondary (originally 1968), by Flavin. This installation is in three rooms and uses nine halogen tube lamps.**

19

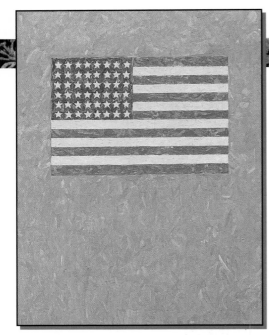

# Neo-Dada

During the 1950s, some American artists were not attracted to abstract art in any form—Expressionist or Minimalist. Instead, they were interested in objects in the world around them and were inspired by the antics of the Dada artists 30 years earlier to take a playful attitude toward art. They introduced popular images of contemporary America into their work, and then personalized them with some painterly elements. This movement lasted from about 1957 into the 1960s and was labeled Neo-Dada (New Dada). The leading artists were Robert Rauschenberg (b.1925) and Jasper Johns (b.1930).

## The art of the ordinary

Johns is famous for paintings of the American flag and other ordinary subjects, such as maps of America and targets. These were painted in a straightforward way, yet made curious and interesting by the painterly brushwork. He also produced a large number of pictures combining techniques of collage and photomontage, as pioneered by the Cubists and Dadaists. In these, as with his American flag paintings, he liked to use elements that had not appeared in traditional pictorial art.

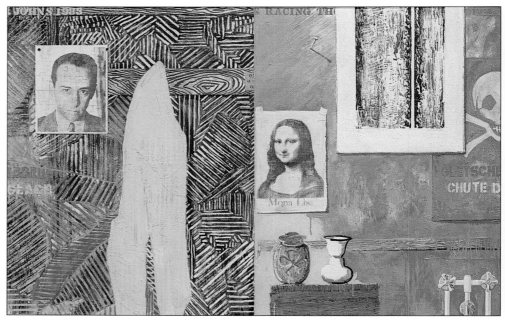

Racing Thoughts (1983), by Johns. Here, in a deliberately confusing mix of techniques, Johns uses photomontage (including a "ready-made" reproduction of Leonardo da Vinci's most famous painting, Mona Lisa), stenciled lettering, still life, and abstract art to create a strangely harmonious image. Note the painted nail (and its shadow) above the Mona Lisa.

Johns's friend Robert Rauschenberg used similar techniques and came to public notice with some extravagant Dada-like gestures, such as his famous piece called Monogram (1959).

# Around the World
# France

As Neo-Dada developed in the U.S., a similar movement was evolving in France. The artists involved included Arman (b.1928), César (1921-98), Daniel Spoerri (b.1930), and Jean Tinguely. They too were inspired by Dada and their use of "found objects." Arman made collages out of cheese wrappers, old sheets, shoes, and eggshells, and created a series called Poubelles (Garbage Cans).

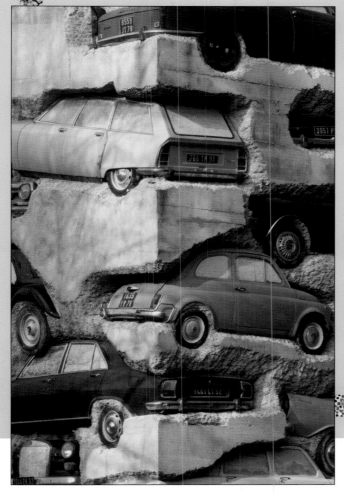

## Scrap art

This kind of art was labeled Nouveau Réalisme ("New Realism"). It focused on the use of discarded objects and urban waste. In the U.S. a similar movement was termed Junk Art. Spoerri produced what he called "trap pictures" recording ordinary daily events—for instance, a collection of old dishes that suggested a meal trapped in time. Both Arman and César liked to work on a large scale and made sculptures of crushed vehicles encased in concrete. César made a name for himself through his use of crushed and compressed scrap metal.

**A tower of cars encased in concrete, one of many works by César which he entitled Compression.**

*Monogram* was a stuffed long-haired goat with a tire around its belly, splashed with paint. Rauschenberg calls his approach to art, using paint, collage, and objects, "combine painting."

These works caused much controversy. Critics felt that they, and art generally, were being mocked. But by creating works using nonart contents, the Neo-Dadaists hoped to broaden viewers' perceptions of art. Their attitude to consumer society had a major influence on the next big art movement—Pop Art.

**Rauschenberg caused a storm when he won the Grand Prize at the 1964 Venice Biennale. A Vatican newspaper said the award represented "the total and general defeat of culture."**

21

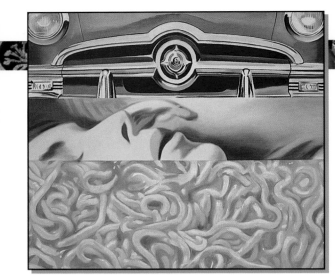

# Pop Art

Back in Britain in the 1950s, the artist Richard Hamilton (b.1922) was pursuing a path similar to that of the Neo-Dadaists. He cut out images from magazines—often from advertisements—and pasted them together to make a picture. On the one hand, these works poked fun at the commercial world and consumer society. On the other, they gave commercial products a certain artistic value and glamor. Suddenly artists on both sides of the Atlantic began to explore the artistic possibilities of imitating commercial imagery—of making art out of popular culture.

## Art meets the consumer world

In 1956, Hamilton said that he wanted art to be "popular, transient [short-lived], expendable, low-cost, mass-produced. . . witty. . . gimmicky." He might have been predicting the future, for this is what happened—mainly in the U.S. By the 1960s, a new movement in art had emerged, called Pop Art.

Pop Art looked at the relationship between commercial art and fine art. We take commercial art more or less for granted— we do not tend to think of labels from soup cans or pictures in advertisements as art. But the Pop Artists borrowed directly from these, played around with them, then presented them as art. This was not quite the same as using a "ready-made," which involved using a manufactured object as a work of art. Instead, the Pop Artists reproduced popular images through painting or printing.

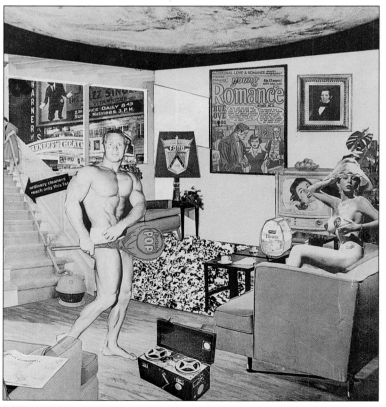

**Just What Is It That Makes Today's Homes So Different, So Appealing? (1956), a collage by Hamilton. This jokey image of consumer paradise is said to be the first Pop Art work and, curiously, the muscle man is holding a lollipop with the word "Pop" on it.**

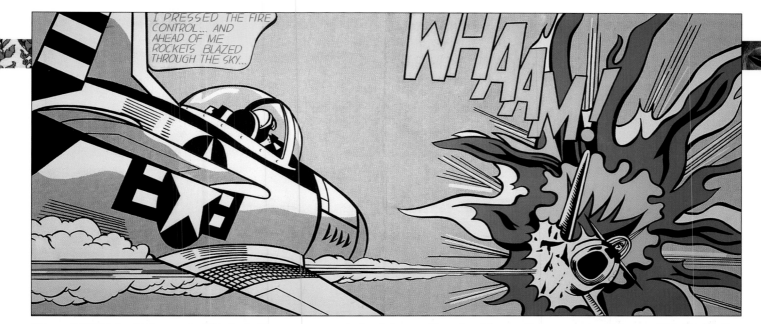

**Whaam! (1963), by Lichtenstein. This looks like a cartoon strip, but it is actually painted in acrylic on canvas and is over 12 ft (4 m) wide.**

They often repeated them or enlarged them dramatically. In *I Love You with My Ford* (top left), the American painter James Rosenquist (b.1933) combines a romantic image of a girl's face (as in a perfume advertisement) with the front of a car and canned spaghetti. But this is an oil painting, over 6 feet (2 m) high and wide.

Fellow American Roy Lichtenstein (1923-97) homed in on the comic strip. He reproduced

## Ben Day dots

If you look closely at a printed color picture through a magnifying glass, you will see a mass of tiny dots in just three primary colors: yellow, blue, and red—plus black. Because the dots are so small, the eye mixes the colors together. In comic strips, texture and shading is created by a cruder process, by laying down sheets of dots, called Ben Day dots (after the American printer who invented the process). Lichtenstein's work is based on a kind of joke. Printers use the dots of the four-color printing process to reproduce photographs of works of fine art. Lichtenstein did the reverse—he made original paintings by reproducing the dots in blown-up versions of the cheap commercial art in cartoons.

the dot effect of the four-color printing technique on a massive scale, complete with speech balloons, to turn a familiar kind of mass-produced art into something monumental. Images appeared completely out of context, and took on a different significance. In *Whaam!* the violence of the event pictured is shown as exciting, almost amusing. As Lichtenstein put it, "One of the things a cartoon does is to express violent emotion in a completely mechanical and removed style." Lichtenstein posed interesting questions about other art techniques. In his *Big Painting No. 6* (1965), he reproduced an Abstract Expressionist swirl of paint, enlarged, using cartoon-style dots.

Like Marcel Duchamp and his "ready-mades," the Pop Artists demonstrated that art is largely about selecton.

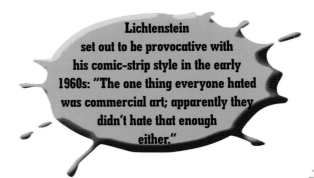

**Lichtenstein set out to be provocative with his comic-strip style in the early 1960s: "The one thing everyone hated was commercial art; apparently they didn't hate that enough either."**

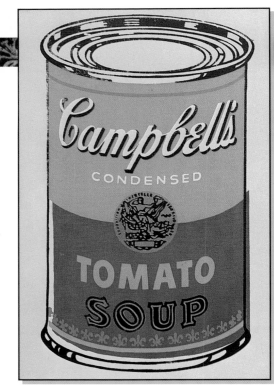

# Warhol

The most famous of the Pop Artists was the American Andy Warhol (1928-87). Born in Pittsburgh to Czech parents, he began his career as a commercial artist making advertisements, and enjoyed immense success during the 1950s. In the early 1960s, he started to make paintings and three-dimensional works, using familiar consumer products and images, such as Coca-Cola bottles and boxes of Brillo pads as his subject matter. When his painting of Campbell's tomato soup cans were exhibited in 1962, he shot to fame. But many people were bemused. Was this art? Warhol enjoyed the controversy and became the acknowledged leader of the new Pop Art movement.

## Mass-produced art

Warhol was intrigued by the consumer world and mass production, and their relationship with art. He began now to use silk-screen printing to make his pictures. Glamor and fame became a central theme, and he produced numerous works featuring well-known stars of music and film, such as Elvis Presley and Marilyn Monroe.

Silk-screen printing creates flat areas of a limited number of colors. The result was a depersonalized kind of art, with little of the creativity or artistic expression usually associated with painting. This was just the kind of impression that Warhol wanted to make: he wanted to provoke viewers into saying, "But I could do that!"

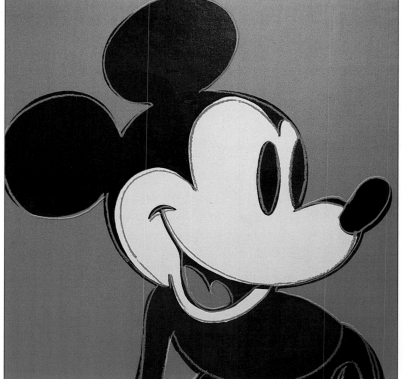

**Mickey Mouse (1981), a silk-screen print from Warhol's Myth Series. Warhol has taken a straightforward image of Walt Disney's most famous character and blown it up to 5 feet (1.5 m) wide.**

# Silk-screen printing

Warhol was one of the first to use silk-screen printing to produce paintings. This is a method of printing where paint is pushed through holes in a cutout stencil to create an image. A fine-mesh screen is stretched over the stencil. Originally this screen was made of silk, but now it is usually made of artificial fibers. One color of paint or ink is poured over the screen, pushed through the mesh and onto a blank sheet of paper. Where the stencil is, the paper remains white. Numerous copies of the image can be made in this way. Different areas of color can be added by cutting out new stencils and printing from them, using different colors.

Yet in a subtle way, silk-screen prints do have some quality of handmade craftsmanship, so collectors could feel that they were purchasing a work of art that had been personalized to some degree.

Warhol sometimes used his technique to produce shocking images—pictures, for instance, of car crashes. But by repeating the image many times over in a single print, the horror is softened into a posterlike image. It is as though he, as an artist, saw a soup can and a wrecked car in the same cold light—as visual objects. Indeed, he claimed his work was simply visual, with no deeper significance.

> **Warhol claimed that, through the growth of mass communications, "in the future everybody will be famous for 15 minutes."**

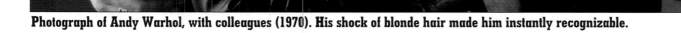

**Photograph of Andy Warhol, with colleagues (1970). His shock of blonde hair made him instantly recognizable.**

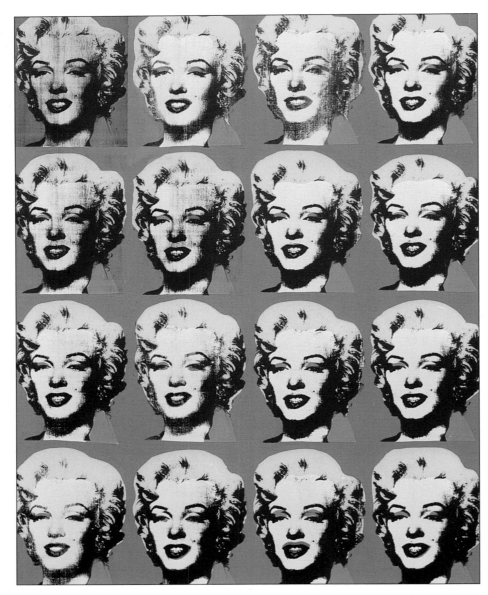

Twenty-five Colored Marilyns (1962), by Warhol. This was one of many silk-screen prints by Warhol featuring Marilyn Monroe, a major film star who had died earlier that year. The use of unnatural and poorly positioned colors recalls low-cost printing techniques of mass-market publications. This, and the repetition of the face, creates a haunting image.

In 1968, an actress in one of his films shot Warhol, seriously wounding him. He never fully recovered his health, but the incident increased his fame yet further. Just like the world of advertising from which he drew his ideas, Warhol courted publicity. He wanted his art and the artists around him to be in the news, and he loved to be surrounded by celebrities. But Warhol himself remained a rather strange and quiet character in the midst of all this mayhem, enjoying being mysterious. He kept baffling commentators by glorifying utterly ordinary things and consistently failing to say anything profound. Indeed, he made it his practice to appear boring. "I want to be a machine," he once said.

Warhol was perhaps best at self-promotion—he knew that it was better to let the art press explain his work. If success can be measured in money, he was one of the most successful artists of all time. When he died unexpectedly, at age 58, following a routine operation, he left $100 million—mostly to his arts charity, the Andy Warhol Foundation.

## Fame and fortune

Warhol set up a studio in New York, called The Factory, where assistants churned out silk-screen prints under his instruction. The Factory also made controversial movies, such as *Sleep* (1963-4), a six-hour film simply showing a man sleeping, and *Empire* (1964), an eight-hour film showing the Empire State Building from one camera angle, as the light changes. Warhol sponsored a rock group called The Velvet Underground, and was at the center of a wild bohemian group that often drew the attention of the press, not always for attractive reasons. Drugs and violence both played a part in the story of The Factory.

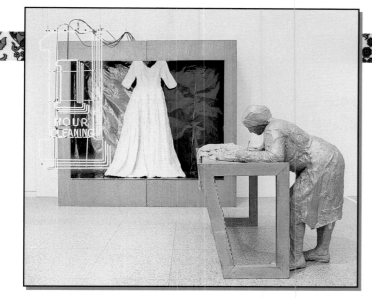

# Pop Art Sculpture

A number of the Pop Artists made sculptural, three-dimensional pieces. Like the painters, they took the commercial world and consumer products as their starting point. Instead of trying to create sculpture of great beauty, they made reproductions of articles from everyday life, but in surprising material or on a surprising scale. The American sculptor George Segal (b.1924) made unpainted plaster casts of real people, seen as if frozen in some routine activity and surrounded by real everyday objects. It is as though the viewer is suddenly given permission by the artist to see everyday life as art.

**Sewing Machine (1961), by Oldenburg. The artist has used plaster, textiles, wire netting, varnish, and paint to create a roughened, sculptural image of an utterly ordinary manufactured object.**

## Soft machines

The painter and sculptor Claes Oldenburg (b.1929), a Swedish-born American, produced a series of witty "soft sculptures" out of cloth stuffed with kapok, with subjects such as a giant hamburger and a tube of toothpaste. On the one hand, they ask questions about the nature of art—can a giant hamburger be art? On the other hand, they ask questions about the artistic quality of ordinary things around us—isn't there some kind of wondrous beauty in a toothpaste tube? Oldenburg also made plans for "Colossal Monuments," such as his *Colossal Ashtray with Fag Ends* (cigarette butts), erected at the Pompidou Center in Paris in 1977.

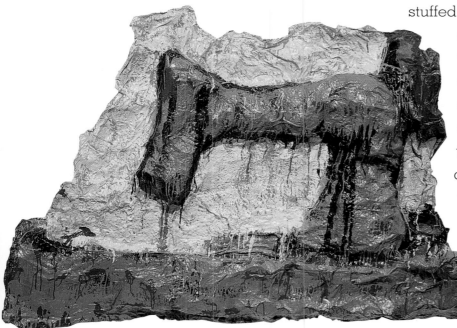

# Op Art

Since the beginning of the history of painting, artists have known that the human eye can be tricked. A visual trick that can be played by lines or clashing color in drawings is an effect known as an optical illusion. Following the development of abstract painting, artists noticed that paintings could achieve a sense of vibrancy if this effect was deliberately exploited. The Hungarian Victor Vasarely (1908-97) started doing work of this sort while living in Paris in the 1930s.

In 1964, in the wake of Pop Art, his kind of painting was jokingly labeled Op Art (from Optical Art).

## Art of illusion

In some works, such as *Alphabet A.B.C.*, Vasarely uses shapes and contrasting colors to make the eye "swim." Elsewhere he creates illusionary three-dimensional effects, as seen in *Vega-Pal*. The results can be strangely hypnotic. By the mid-1960s, Vasarely had become world famous, especially after an exhibition called The Responsive Eye at the Museum of Modern Art in New York.

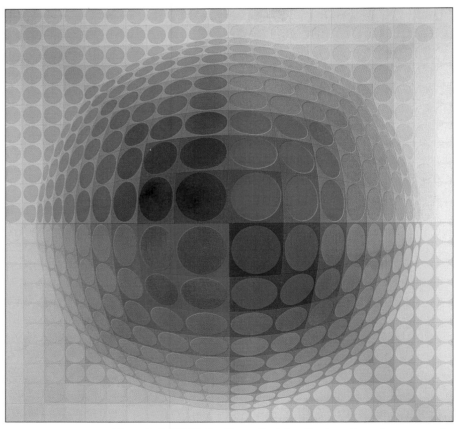

**Vega-Pal (1969), by Vasarely. The illusion of a sphere emerging from a flat background became a major theme for Vasarely.**

Meanwhile, a new generation of Op Artists had emerged. The most famous among them was the British painter Bridget Riley (b.1931), who massed sharp-edged, thin lines on large canvases to create images that seemed to vibrate and throb.

By the early 1970s, the public had grown tired of Op Art's aim to produce patterns that play tricks on the eyes. However, both Vasarely and Riley continued working.

Vasarely pursued the idea of making art more "democratic," accessible to all, and less concerned with the personal expression of individual artists. During the 1950s, he had produced small pieces of metal and plastic on which shapes were printed. The idea was to manufacture these as a commercial venture, so that everyone could be an artist and make their own Op Art pictures and murals. However, the kits proved too expensive and did not catch on.

Op Art depends on the confusion of the eye that comes from the clash of colors and the effect of lines placed very close together. The brain, working hard to compensate, sees after-images and vibrations that do not exist in the real image. To produce the desired result most effectively, the image has to be painted with great precision, which explains the crisp finish of most Op Art. In recent years, a new kind of computer-generated optical illusion called Magic Eye has proved capable of producing a powerful three-dimensional illusion hidden in patterns within another picture.

# Around the World
## Australia

Australian Aboriginal art has a history stretching back many thousands of years. The main subjects are people, animals, and spirits. The paintings usually have a spiritual significance—like everything in the Aboriginal world. Some of the figurative paintings have an X-ray effect, where the internal organs are represented within the body shapes.

### Dot painting

Aboriginal art has been encouraged by the Australian government since the 1970s. A feature of modern Aboriginal art is the use of hundreds of dots. No optical illusion is intended, however—this is simply a way of building up an image. The style is said to originate from the tradition of sand painting, but in modern painting the technique of dotting and overdotting was pioneered by Johnny Warrangkula Tjupurrula (c.1925-2001). Aboriginal painting is now widely collected, and has had a great influence on the work of a number of Western artists.

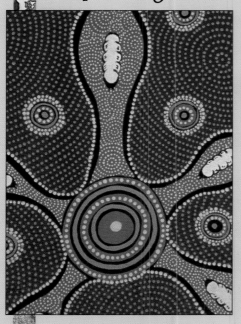

**A modern Aboriginal bark painting, in acrylic.**

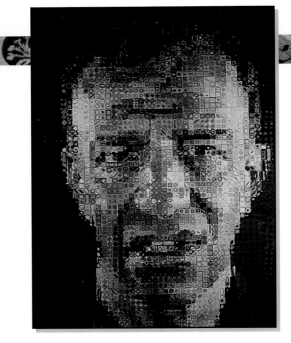

Alex (1991), by Close.

# Superrealism

In the 19th century, a number of artists had developed a very precise technique of painting that produced almost perfectly lifelike images of people. In the 1960s, several American and British artists decided to take the same approach to the modern world. They produced paintings of people and street scenes that were so accurate that they looked like large, high-resolution photographs. In effect, they took figurative painting to its logical conclusion. But was it worth it, if photography could do the same so much more easily?

## High-resolution painting

Somehow, because these pictures were paintings and not photographs, they seemed to have a greater weight and greater sense of timelessness. Yet the effect was also strangely impersonal and emotionally cold. This style of painting became known as Superrealism or Photorealism. The best-known artists in the field were Americans Chuck Close (b.1940) and Richard Estes (b.1936). Close specialized in portraits, usually very large and close-up. More recently, he has replicated special effect photography, where the image is broken up into small dots or squares, as seen in *Alex* (above).

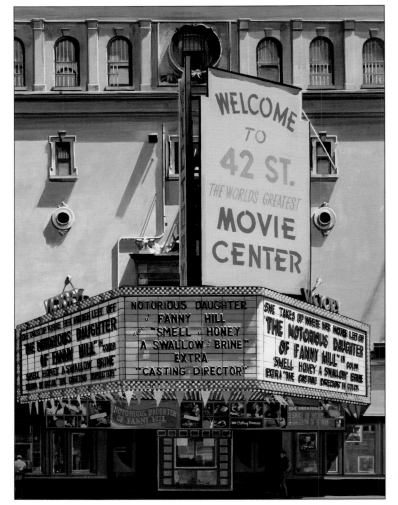

Welcome to 42 St. Movie Center, by Estes.
His skill in rendering perspective can be seen in the receding lettering in the side panels, where the movie titles are shown.

Estes paints cityscapes, rejoicing in the reflections in puddles and car polish. Every little detail is observed, making them hard to distinguish from photographs.

# Around the World
# India

India makes more movies every year than any other country in the world —about 850. Hollywood comes only second, with about 570 a year. The center of the Indian film industry in Mumbai (Bombay) is jokingly referred to as "Bollywood." With so many films, there is big competition to win audiences. One means of enticing the public is through large posters.

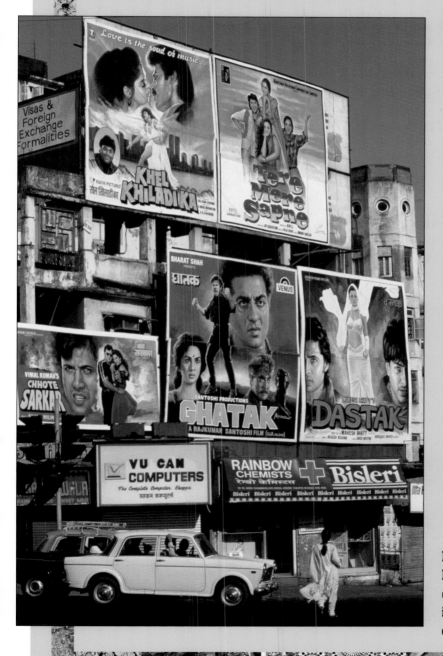

## Film posters

Indian film posters do not show photos of the stars. Instead, they follow the old movie tradition of using paintings, usually of the stars in their roles in the films. The artists use a highly realistic style based on photos. But this is not photorealism. The portraits are idealized and romanticized, with the colors manipulated and exaggerated to draw the eye of passersby. Most Indian films are thrillers or romantic movies, action-packed, with extravagant sets and plenty of singing and dancing—fantasies that allow the audience to escape the realities of their daily lives. The job of the poster is to sell this fantasy, and to promote the stars in the best possible light.

**Hollywood film posters in Mumbai. Is this a photograph or a painting? It is actually a photograph, but the fact that it is not easy to tell demonstrates the skill of Richard Estes' painting opposite.**

# Performance Art

Back in 1916, the Dadaists at the Cabaret Voltaire in Zürich put on wacky performance events, mixing theater, music, and art, as part of their move to reinvigorate art.

In the early 1950s, musicians, dancers, writers, and artists, such as Robert Rauschenberg, put on similar performances at the Black Mountain College in North Carolina. Many of these were one-off events, performed without a script, unrepeatable, and often incomprehensible. But they conveyed a mood or a notion in a way that no other art form could do. These so-called "happenings" were the start of what later became known as Performance Art.

## Around the World
## Japan

Performance Art borrows from the traditions of ritual and theater. Ancient Japanese Shinto temple dances include masked characters, as do the Noh dramas, which date back to the 14th century. Given this heritage, it is perhaps not surprising that Japan produced some of the early pioneers of Performance Art, at the same time as the first American "happenings."

Modern Japanese masks, based on traditional designs.

### Pioneers in Performance Art

From 1954, the Gutai Group, based in Japan, staged a series of performances. Saburo Murakami (1925-96), for example, hurled himself through gold paper screens. Kazuo Shiraga (b.1924) battled with piles of mud, in an artistic event that doubled as an endurance test.

## The art event

Artists such as Oldenburg and Warhol took up Performance Art as part of their work. These performances could vary hugely. Sometimes they were short events, performed before an audience in a gallery. Sometimes they took place in industrial sites or with no audience at all. In some cases, the event resulted in an art product, such as a painting.

Performance Art and "happenings" became a widespread phenomenon in Germany, where the international Fluxus movement was founded in 1962. One of the leading figures was Joseph Beuys (1921-86). His performances were often designed to shock the audience into viewing the world in a different way.

## Body Art

During the 20th century, some artists decided not simply to make paintings or sculptures of the human form, but to use the human body itself. During the 1960s, the French artist Yves Klein (1928-62) created paintings by making nude models, smeared with paint, roll around on a canvas. The Italian artist Piero Manzoni (1933-63) proposed using real bodies as living sculptures. Some artists have also explored the taboos about the body, making artworks out of body parts (such as blood and excrement), or wounding themselves. This is an extreme example of the way artists have felt obliged to challenge public attitudes toward the nature of art.

**The Big Blue Anthropometry (1960), by Klein. This is the imprint of a woman's body smeared in "International Klein Blue."**

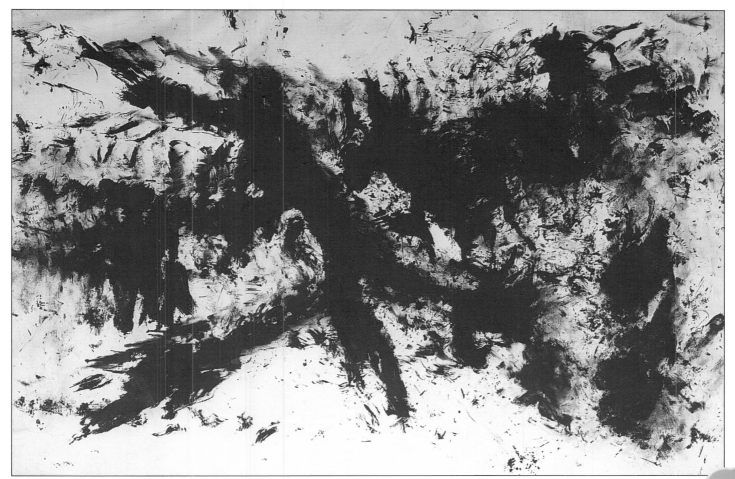

# Conceptual Art

Performance Art was part of a broader trend that shifted the focus of art away from the art object (a painting or sculpture) toward the concept behind it. Marcel Duchamp had pointed art in this direction with his "ready-mades" in 1913. Increasingly, artists were now looking for appropriate new ways to convey ideas, abandoning traditional techniques and materials. The broad term used to describe this development was Conceptual Art. The German artist Joseph Beuys (1921-86) was a leading figure in this movement.

## The art of ideas

Much of Beuys' work concerned the temporary nature of things. For example, he assembled massive, natural-looking lumps of rock with holes drilled in one end. They represent millennia of geological history, yet he called the piece after a moment in time—*The End of the 20th Century*. We are invited to think not so much about the objects themselves, but about the concept that led the artist to select and present them in this way.

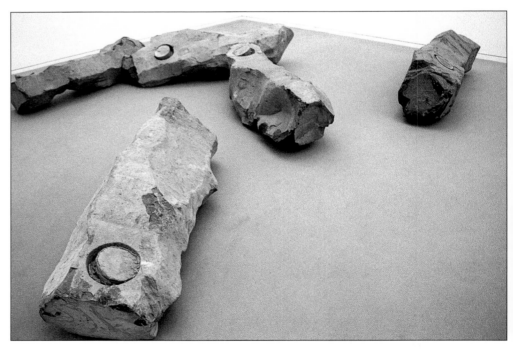

**The End of the 20th Century (1983), by Beuys. This installation consists of basalt stones with drilled holes containing felt and clay.**

Conceptual artists had to produce work that conveyed their concept well. There was no point in producing objects that could only be understood by reading a long explanation. Explaining too much suggested that the object did not effectively convey the message.

As a result, the worst examples of Conceptual Art left viewers either baffled or asking, "What's the point of that?" The best examples presented a new and interesting way of seeing things, in a way that seemed totally appropriate.

**Objet Cache-Toi (Hide-and-Seek Object) (1968), by Merz. Made of metal, wire netting and textiles, with lettering in neon lights.**

Mario Merz wanted to include a live python in his work presented at the 1979 Sydney Biennale in Australia. The organizers were not eager, and resisted!

Conceptual artists have many techniques—installations, performance, videos, or a mixture of these. In his series of installations called *Objets Cache-Toi*, Italian artist Mario Merz (b.1925) used a variety of materials to create igloo shapes suggesting shelter and privacy (or lack of privacy), and labeled in writing made out of neon tubes. Merz was part of a group called Arte Povera, which used rough, low-cost materials to construct pieces of art, similar to the French Nouveau Réalistes, but with more concept-driven intentions.

Conceptual artists do not necessarily reject traditional methods of making art. They may even use painting. One strand of Conceptual Art is called Appropriation—artists treat images from the work of other artists as "ready-mades" and set their work in a new context, questioning the meaning of originality.

Conceptual Art is such a broad term that many artists working in this field do not use it. By some definitions, the movement came to a close in the 1970s, when the art world and public began to tire of its minimalist products. Challenging, idea-based work since this time, showing greater verve and often borrowing from past styles, has sometimes been called Postmodernist. But Conceptual Art remains a useful term when describing art in which the idea is more important than the object presented.

# Neo-Expressionism

By the late 1970s, several artists had grown tired of the emotional coolness of geometric abstract art, Minimalism, and Conceptual Art. They had also become disenchanted with the new mood in art in which anything could be called art. So they returned to painting, and painted with high emotion, expressing themselves with rather crude drawing in colorful paint, often on large canvases. Because they shared some of the features of the German Expressionists of the early 20th century, they were called Neo-Expressionists.

## Torment

A key influence on the Neo-Expressionists was the British artist Francis Bacon (1909-92). From the 1940s, he had been painting with traditional materials (oil on canvas), but his subject matter was highly charged with emotion—he painted monstrous figures, often repulsively expressive of anguish or anger. He also painted portraits and characters from the Old Masters, such as Velázquez, reworked in his same unmistakable style.

By the late 1970s, Bacon was nearly 70 years old. The Neo-Expressionists belonged to a much younger generation. Their paintings expressed an even greater sense of raw energy and artistic freedom.

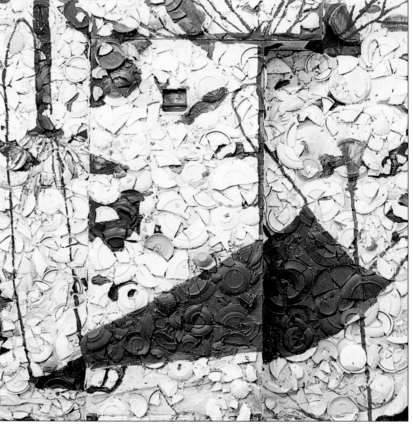

Circumnavigating the Sea of Shit (1979), by Schnabel. This work can be seen as a direct response to Minimalism and coolly controlled abstract art. Nearly 8 feet (2.5 m) wide and high, it is made up of broken plates and wooden boxes, as well as crudely applied paint.

The American Julian Schnabel (b.1951) was very successful. Like the other Neo-Expressionists, Schnabel often added material to the painting, such as broken plates or rags, to create a more expressive surface. The effect is often unsettling.

The best-known group of Neo-Expressionists was German. They were sometimes called the Neue Wilden (New Wild Ones, like the Fauves). Georg Baselitz (b.1938) made a name for himself by painting figures upside down, to make the paintings look more abstract and less recognizable. Crudely drawn in thick paint and unnatural colors, his paintings show a direct link with the Expressionists earlier in the century. He has also made sculptures of figures carved out of tree trunks with a chain saw, but these are the right way up. Anselm Kiefer (b.1945) painted vast, somber, and thought-provoking canvases, often of tragic or historic images that rake over Germany's tormented history, notably its Nazi past.

**Adelaide, by Kiefer. Much of his work involves painting with oil on canvas, often on a huge scale. But he is also known for his mixed-media work and installations. Airplanes and charred nightshirts are recurrent themes, suggesting a world of dreams and nightmares.**

# Found objects

Much of the work of the Neo-Expressionists, especially Schnabel and Kiefer, includes "found objects"—things from daily life that the artist has found and used in a piece. This has been a practice since the Cubists first used pieces of printed paper in their collages in about 1911. The term is a translation of the French *objet trouvé*. Earlier artists tended to use found objects in a whimsical way, often to create a sense of surprise, or to connect the viewer with the everyday world. In the case of the Neo-Expressionists, found objects have been used to convey a strong emotional charge. Schnabel's broken dishes express in a very direct way the violent energy that has been used to shatter the plates.

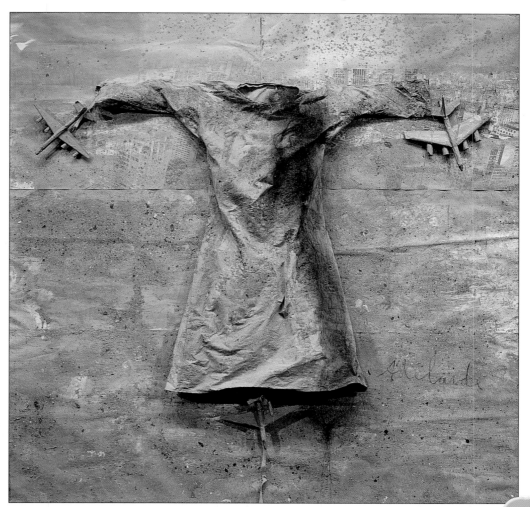

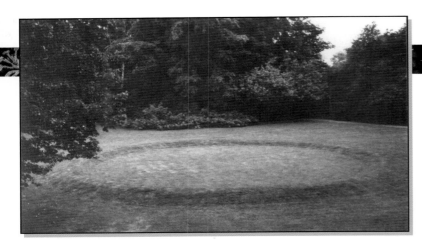

# Land Art

One development of the late 20th century has been to take art outside the confines of art galleries. With Land Art (also called Earth Art), artists create a work in a landscape. The American Walter de Maria (b.1935), for instance, made a piece consisting of two parallel lines across the Mojave Desert in the southwest U.S. Fellow American Robert Smithson (1938-73) built a large spiral earth ramp in the Great Salt Lake of Utah. Land artists sometimes make only a small gesture, letting the landscape itself play the major role. Again, it is often the selection that makes the art. Land Art falls somewhere between Minimalism and Conceptual Art.

## Walking for art

The British artist Richard Long (b.1945) is one of the world's best-known Land artists. His work involves taking long walks in remote places, often in beautiful landscapes. He may make no more than tiny changes to the landscape, such as moving pebbles into a line, but he also creates more sculptural works using naturally occurring parts of the landscape, as in his *Turf Circle* (above).

**Walter de Maria, photographed with his piece of Land Art called Sphinx (1968), in Hamburg.**

Land Art gave artists a new freedom. They could work on any scale, and their products could never be captured and put in a gallery, be owned, or become a part of the art market. However, this left them with the problem of how to present their work. Clearly, the public could not always be expected to go and see the work for themselves—the work, in any case, is often short-lived. So Land Art is often recorded in photographs.

For his piece called *A Hundred Mile Walk* (1971-72), Long walked for several days in a circle in Dartmoor, an area of wild moorland in southwestern England. He recorded this in a small image consisting of a map showing the walk, a series of short written poetic statements, and a photograph of the landscape.

# Around the World
## Peru

The most extraordinary examples of Land Art were made over 1,000 years ago, in the coastal desert of Peru. Vast lines were drawn across the desert over an area of 200 sq mi (500 sq km). Some of them are geometric patterns, others are images of animals, such as monkeys or birds. They can be seen only from the sky, which led some people to speculate that they had been made with the help of some alien power from space.

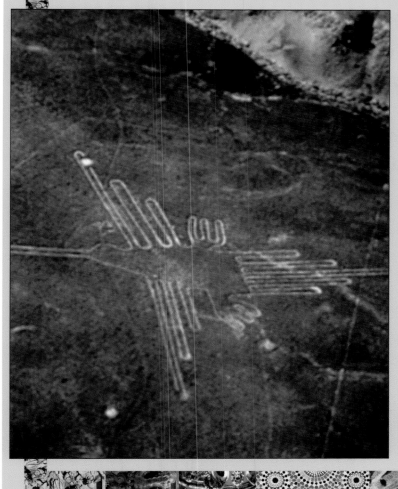

### Ritual paths

A more plausible explanation has recently emerged. It seems that these lines were connected to the religion of the Nazca people who made them. Their holy places were in the mountains, the source of vital water for farming this arid land. Their gods were animals connected with the mountains and water. These huge drawings, it seems, were paths laid out for ritual processions in praise of the gods.

**Aerial photograph of a stylized hummingbird, one of the huge emblems found among the Nazca lines traced out in the coastal desert of Peru.**

**Earth Room by Walter de Maria** is a room filled with earth, to a depth of about 7 ft (2 m). The viewer can see it from behind a sheet of plate glass.

Alternatively, the Land artist may make an installation in a gallery using certain elements from the natural landscape. Walter de Maria does this with his *Earth Room and* Richard Long does it with a piece named *Slate Circle* (top left).

# Video and Photographic Art

By the 1980s, many artists had seen the potential of using video to create works of art. Images could be shown on a single screen, accompanied by a soundtrack. By using a number of screens together, a new sense of dynamism could be introduced. Sometimes the images were just a mosaic of different or related pictures; sometimes they told a brief story. But video art had to be more than just a short film. Usually it had a heightened feel for observation, achieved through the selection of material, the way it was filmed, and the way it connected with other images.

## Moving pictures

The video art movement can be traced back to *13 Distorted TV Sets* (1963), a work by Korean artist Nam June Paik (b.1932) and the German Wolf Vorstell (b.1932). As Paik once said, "TV has attacked us all our lives; now we are fighting back." Paik remains a leading figure in video art, known for his multiple-screen installations. His *Fin de Siecle II* (1989) used 200 television sets controlled by computer. He has also built more fanciful assemblages incorporating video screens, such as *Marco Polo* (above).

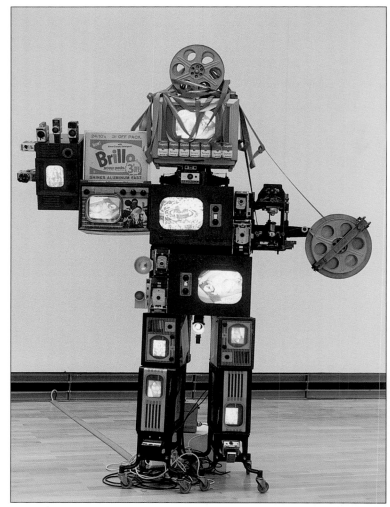

Paik's Andy Warhol-Robot (1994) extends the concept of Performance Art.

Video art became increasingly sophisticated in the 1990s, as galleries installed wide-screen facilities. One of the leaders in the field is the American Bill Viola (b.1951). His films about birth and death have won international acclaim.

Still photography is also widely used as an art medium. Modern techniques have permitted large, high-resolution images and manipulation of image and color. British art duo Gilbert and George (b.1943, b.1942) mix Performance Art with Body Art. The result is often expressed in panels of dyed photographic prints, looking almost like stained glass, with the artists themselves as the main subject.

The American-born artist Susan Hiller (b.1942) has used both video art and photography as part of her exploration of human behavior. But in her case she uses whatever medium she feels best suits her purpose—sculpture, paintings, found objects, light, or sound.

## Video

Video art has progressed by leaps and bounds since the 1960s, along with technology. It is likely to change again, as digital processes join forces with computer-based editing. With video art shown on a single screen, artists face the difficulty of presenting images that are radically different from those seen on a TV or computer monitor. A multi-screen presentation presents new opportunities. The interweaving of different images across a collection of screens can set up curious relationships between images—imitating, for instance, the way our brain takes in what we see around us and simultaneously uses memory to interpret the image. Groups of video screens can also be linked together to present components of a single image.

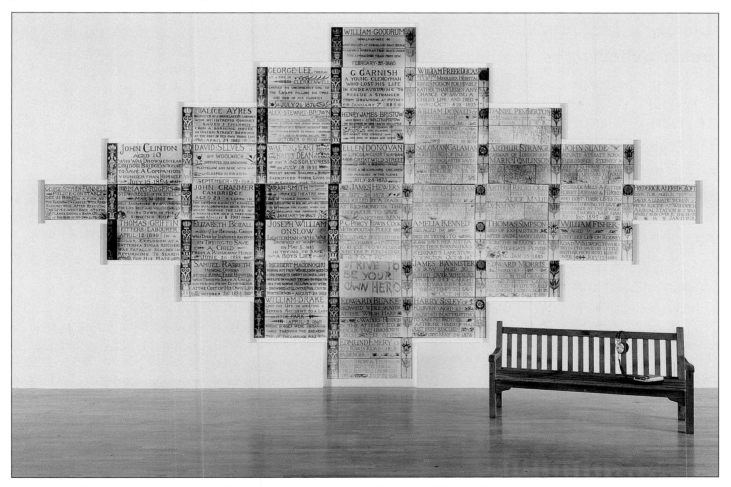

**Monument (1980-81), by Susan Hiller. The viewer activates a soundtrack by sitting on the bench in front of the photographs and so becomes part of the installation as seen by other people.**

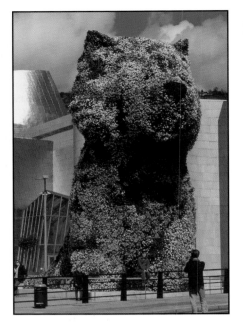

Puppy (1997), by Jeff Koons. It is 42 feet (13 m) tall and made of some 70,000 flowering plants.

# Mixed-Media Installations

The development of 20th-century art has permitted artists to take great freedoms—with their materials, subject matter, and the very meaning of art. The word "installation" has emerged for large three-dimensional works of art that cannot be described as sculpture, often made in a wide range of materials (mixed media). Like Land Art, some installations cannot fit into a gallery. The Bulgarian-American Christo (b.1935) and his partner Jeanne-Claude (b.1935) are famous for wrapping bits of landscape or whole buildings in fabric. Other artists, however, use gallery spaces for their installations, creating effects that no other art form has ever achieved.

## New angles on the world

Installations are designed to be walked around or through. They tend to be made of a wide variety of materials, many of them "found objects." Many installations are temporary, prepared for a particular gallery and then dismantled. The Russian artist Ilya Kabakov (b.1933) creates whole rooms and passages inside a gallery. Viewers walk through the exhibit looking at pictures and objects on display.

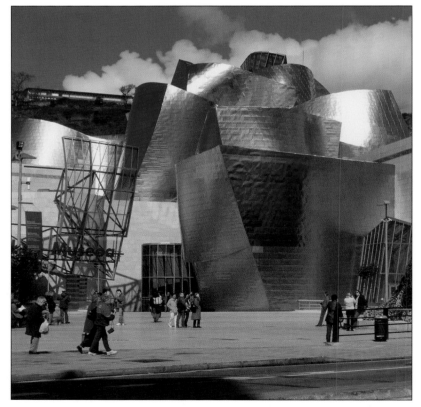

The Guggenheim Museum in Bilbao, Spain was created by Frank O. Gehry (b.1929). It was the first really sculptural piece of architecture purpose-designed as a gallery of contemporary art. Its surface is covered in 30,000 titanium tiles. Outside it stands Puppy (see above).

The American artist Jeff Koons (b.1995) is famous for his witty creations based on popular images and mass-produced objects—products that are often dismissed as "kitsch." The result is work that is absurd, funny, and puzzling, but always made to high standards of craftsmanship.

The self-taught French sculptor Niki de Saint Phalle (b.1930) has been working on witty, colorful installations and sculptures since the 1950s. She is well known for her exuberant fat ladies called Nanas, and sculptures of monsters. Much of her work is in painted polyester and papier-mâché, but she incorporates found objects and collage.

Some mixed-media installations strike a more disturbing note. The British artist Damien Hirst (1965-) shot to fame in the early 1990s with his highly controversial "vitrines"—glass tanks containing dead bodies or parts of real animals.

## Installations

The word "installation" came into use in the 1970s, describing larger versions of what had previously been called "assemblages." There are almost no boundaries to installations. They can consist of empty spaces lit by neon lights. They can be constructions consisting of everyday objects, paintings, or video screens. They can be whole rooms, looking like replicas of existing rooms, perhaps inside a labyrinth of passages. Or they can be vast constructions, covering large areas of landscape. Installations can provide an effective way of saying something new about the world. But the interest of the art world and the public is not unlimited—installations have to deliver some valid notion or concept to justify the space that they take up.

In 1966, Niki de Saint Phalle created "Hon," a sculpture of a woman so big that people could walk inside, watch movies, and view an aquarium.

"Sophie," one of The Three Nanas (1974) by Niki de Saint Phalle, in Hanover, Germany, where it has become one of the city's landmarks. De Saint Phalle has also produced architectural work, books, films, and theater designs and has spent much of the last 25 years working on a sculpture garden in Tuscany, Italy.

43

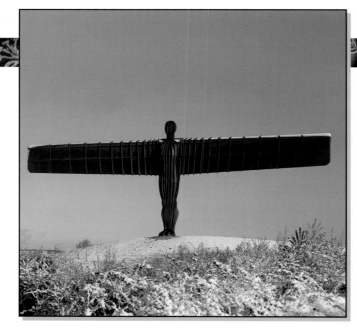

# New Sculpture

The temporary nature of art, and life, has been a key concern of modern art. This was a central theme of Performance Art, for instance. One of the merits of sculpture, however, is that it can be created to last a very long time indeed. Much of what we know about the art of ancient civilizations comes from stone and bronze sculpture. Just when the traditions of stone and metal sculpture seemed to be going out of fashion, a fresh generation of artists arrived to give it a new breath of life.

## In the public eye

Antony Gormley (b.1950) was already celebrated as a leading British sculptor of his generation when he made *The Angel of the North*. Some 65 ft (20 m) high, with a wingspan of 172 ft (52 m), it is not only Britain's tallest statue, it is also one of its best known. Standing beside a busy highway near Gateshead in northeastern England, it is seen by some 100,000 people every day.

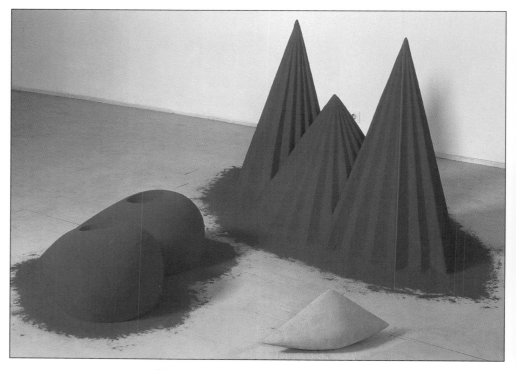

Above: As If To Celebrate, I Discovered A Mountain Blooming With Red (1981), by Anish Kapoor. This sculpture is made of forms covered in powdered pigment.

Right: Maman (2000), by Louise Bourgeois. This 40-ft (10-m)-tall spider was commissioned to mark the opening of the Tate Modern Gallery in London, and dominated the vast space of the Turbine Hall, the main entrance to the gallery.

Much of Gormley's work concerns the human body, often made by taking plaster casts of his own body. In contrast to the giant scale of *The Angel of the North*, he has also made a piece called *Field*, which includes 40,000 miniature figures made out of clay.

Hovering over its six white eggs, Maman (the French for Mommy) is said to reflect Louise Bourgeois' childhood anxieties about her relationships with her own family.

The work of the Indian-born sculptor Anish Kapoor (b.1954) is rather more abstract. He takes large hunks of natural rock and carves smooth geometric shapes into them. By leaving the outer surface rough, he gives his work a timeless, ancient quality—yet its concept as sculpture is utterly modern. He also works in hard resin and stainless steel, as well as powdered pigment and inks of deep color. In his way, he blurs the distinction between sculpture and painting, and plays with contrasts between hard and soft, light and dark, presence and absence.

One of the most inventive sculptors of the 20th century is Louise Bourgeois (b.1911). A French-born American, she moved to New York in 1938 and was in her thirties when the Abstract Expressionists were taking the art world by storm. Her work is full of imaginative surprises, and includes installations of mixed media combined with skilled carving and modeling.

Much of the artistic work produced today will perish and decay. But the work of the sculptors, cast in bronze or hewn from stone, should last. So what will future generations of archaeologists and art historians make of the art of our times?

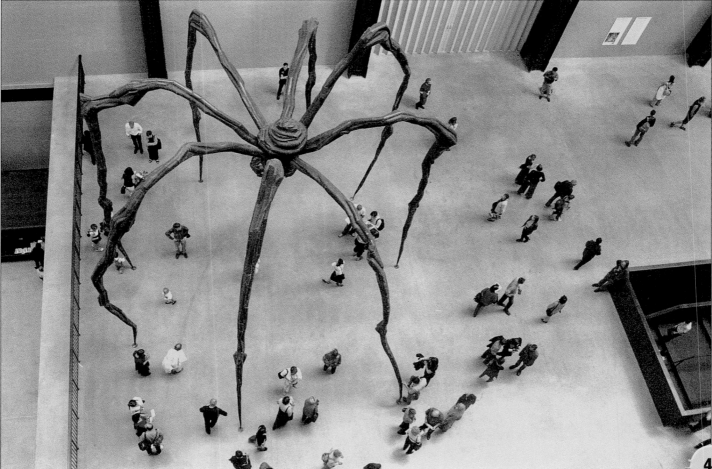

# Chronology of Art in the Late 20th Century

**1932** Duchamp coins the term "mobile."
**1935** The Federal Art Project is set up in the U.S. to help artists during the Depression.
**1937** The Nazis in Germany, led by Adolf Hitler, show their hatred of the avant-garde with a display of "Degenerate Art." Many German, Jewish, and other European artists flee to the U.S. during this period.
**1939** Outbreak of World War II (to 1945).
**1947** Pollock begins painting by "drip and splash." Giacometti begins making his characteristic bronze figures.
**1952** The first "happening" takes place at Black Mountain College, North Carolina.
**1954** Death of Matisse. The Gutai Group of Performance Artists forms in Japan.
**1956** Hamilton creates the first Pop Art work.
**1956** Death of Pollock.
**1962** Warhol exhibits his Campbell's tomato soup can paintings. The Fluxus movement, promoting Performance Art, forms in Germany.
**1963** Paik and Vorstell exhibit *13 Distorted TV Sets*, an early example of video art.
**1965** The term "Minimalism" is introduced. The Responsive Eye exhibition launches Op Art.
**1968** De Maria makes *Mile Long Drawing*, an early example of Land Art.
**1969** Christo wraps a large stretch of the Australian coastline. Conceptual Art becomes an international phenomenon.
**1970** Death of Rothko.
**1973** Death of Picasso.
**1986** Death of Beuys.
**1987** Death of Warhol.
**1998** Gormley's *The Angel of the North* is inaugurated.

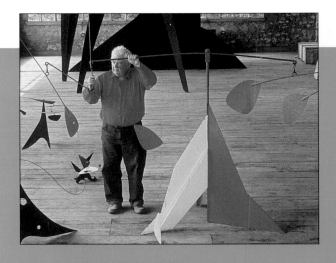

## A Brief History of Art

The earliest known works of art are small, carved figurines dating from 30,000 B.C. Cave painting dates back to 16,000 B.C. Sculpture was the great art form of ancient Greece, from about 500 B.C. Greek sculptors made brilliantly lifelike images.

In Europe, the Renaissance began in the 1300s, when artists in Italy rediscovered the culture of the ancient Romans and Greeks. Renaissance artists include painters such as **Giotto** (c.1267-1337), **Leonardo da Vinci** (1452-1519), and **Jan van Eyck** (c.1390-1441). **Michelangelo Buonarroti** (1475-1564) made sculpture as fine as the Romans or Greeks had produced.

In Europe, Mannerist painters like **El Greco** (1541-1614) were putting emotion into their paintings. Baroque painters, like **Pieter-Paul Rubens** (1577-1640), displayed dazzling technical skill and a sense of glamor. The Dutch painter **Rembrandt van Rijn** (1606-69) showed in his portraits how painting could capture the sitter's character.

Artists now painted detailed pictures of reality, but this was not enough anymore.

Painters like **Francisco Goya** (1746-1828) adapted their style to convey personal expression and emotion. Emotion was a key element of Romanticism. In his late work, **J.M.W. Turner** (1775-1851) used applied dashes of color to convey feeling.

In the Realist movement, artists like **Gustave Courbet** (1819-77) used their skills to portray real life. In the 1870s, Impressionists such as **Pierre-Auguste Renoir** (1841-1919) and **Claude Monet** (1840-1926) took Realism in a new direction. They painted outdoors, and rapidly, trying to capture the passing moments of the world. Postimpressionists, such as **Paul Gauguin** (1848-1903), **Vincent van Gogh** (1853-90), and **Paul Cézanne** (1839-1906) developed highly individual styles.

In the 20th century, a series of movements followed each other. In Cubism, **Pablo Picasso** (1881-1973) explored new ways to look at objects. Expressionism concentrated on putting emotion into painting. The Surrealists, such as **Salvador Dalí** (1904-89) and **René Magritte** (1898-1967), depicted imaginative, dreamlike worlds. Abstract art was taken a step further in the works of **Piet Mondrian** (1872-1944), while **Jackson Pollock** (1912-56) launched Abstract Expressionism. In the late 20th century, Pop artists like **Andy Warhol** (1928-87) explored the meaning

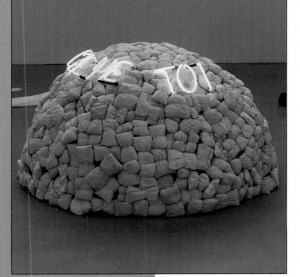

of art, as did Minimalists such as **Carl Andre** (b.1935). Installation artists such as **Joseph Beuys** (1921-86) took art in new directions.

# Glossary

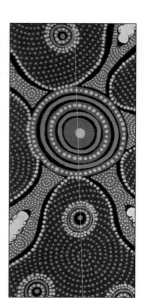

**Abstract art**
Any form of art that does not represent things in the real world, but is composed simply of shapes or colors.

**Avant-garde**
The leaders of new trends in art. The term is from the French for vanguard (soldiers at the head of an army).

**Collage**
The technique of creating images by selecting, cutting out, and sticking down bits of paper and other printed material. The term comes from the French *coller*, to stick.

**Conceptual Art**
Essentially, any form of art in which the idea is more important than the art object itself.

**Installation**
A large three-dimensional work, usually involving mixed media and found objects.

**Mixed media**
A term that refers to a work of art that includes a combination of materials. This might include painting, found objects, video, and photographs.

**Photomontage**
A way of building up an image by using cutout photographs, a technique developed by the Dadaists.

**Ready-made**
A term invented by Marcel Duchamp to describe an ordinary, mass-produced article that becomes a work of art by being selected by an artist.

# Index